D0646729

2005
Veterans Creative Arts
Festival
Best wishes from the American
Legion Auxiliary!

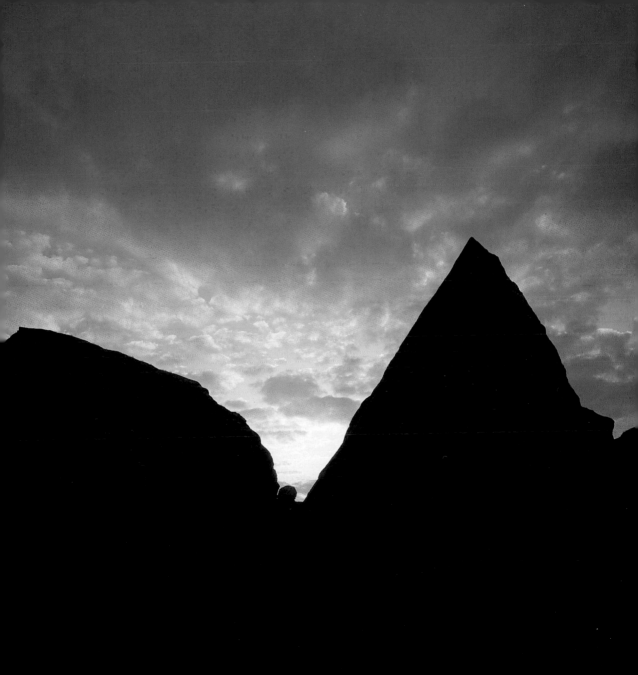

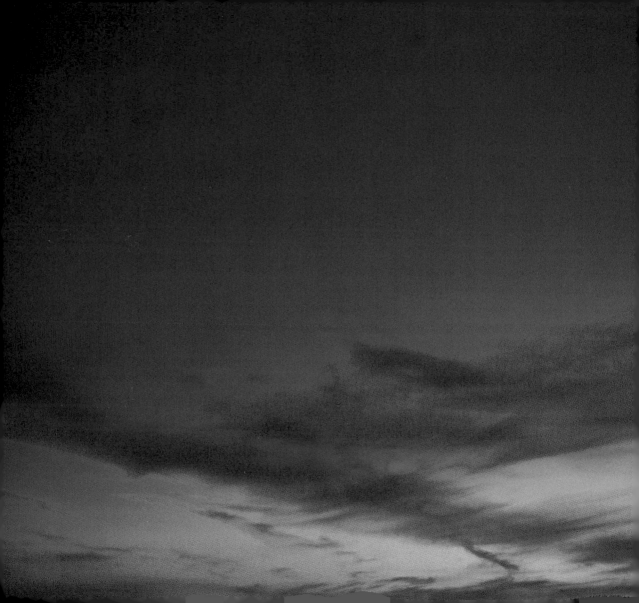

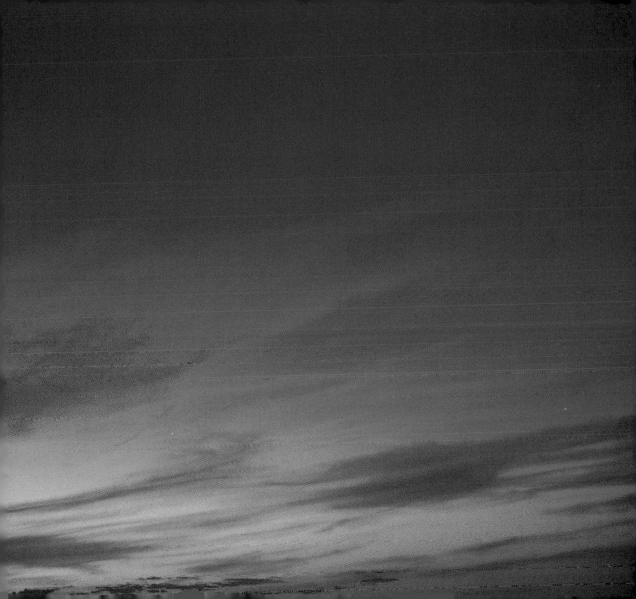

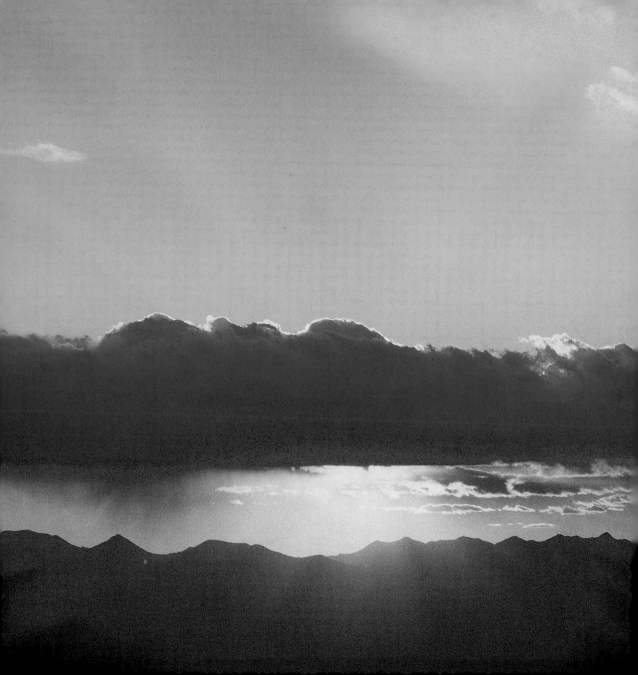

COLORADO SKIES

Photography by
John Fielder
with selected prose & poetry

Colorado Littlebooks

WESTCLIFFE PUBLISHERS

www.westcliffepublishers.com

International Standard Book Number: 1-56579-297-1

Photography copyright 1998; John Fielder. All rights reserved.

Published by Westcliffe Publishers, Inc.
P.O. Box 1261, Englewood, Colorado 80150-1261
www.westcliffepublishers.com

Designer: Craig Keyzer
Production Manager: Harlene Finn
Quotes researched by Dean Galiano

Printed in Hong Kong by C & C Offset Printing Co., Ltd.

Library of Congress Cataloging-in-Publication Data:
Fielder, John.
 Colorado skies / photography by John Fielder.
 p. cm.
 ISBN 1-56579-297-1
 1. Colorado—Pictorial works. 2. Sky—Pictorial works.
 3. Landscape photography—Colorado. I. Title.
 F777.F478 1998
 917.8804'33'0222—dc21 98-2844
 CIP

No portion of this book, either text or photography, may be reproduced in any form,
including electronically, without the express written permission of the publisher.

For more information about other fine books and calendars
from Westcliffe Publishers, please contact your local bookstore,
call us at 1-800-523-3692, write for our free color catalog,
or visit us on the Web at **www.westcliffepublishers.com**.

First frontispiece: *Morning buttermilk clouds over the Sangre de Cristo Range*
Second frontispiece: *Sunset over the Colorado plains*
Third frontispiece: *Sunset over the Sangre de Cristo Range*
Opposite: *Sunrise in the Gore Range*

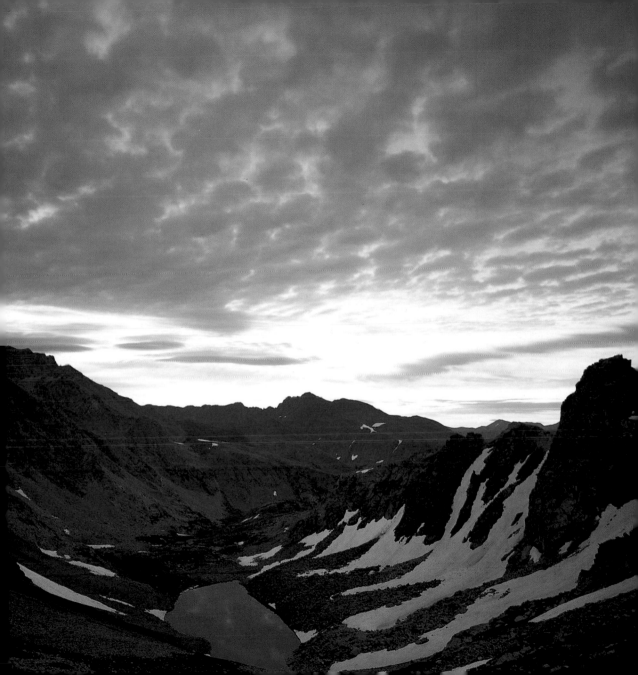

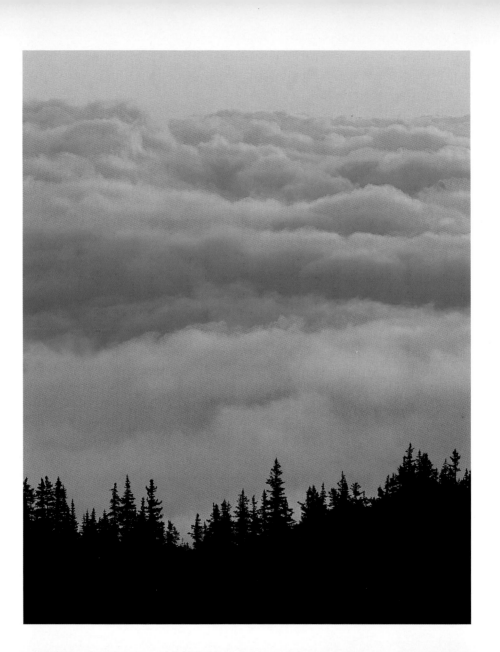

PREFACE

Above all else...

Colorado is defined by the marriage of sky and land. Though mountain meadows and tundra-topped peaks are the firmament of our walks, our eyes probably spend more time pointed upwards than they do towards the ground. Colorado's landscape is as varied as the shapes of a snowfall's worth of snowflakes, but its shapes and settings can't begin to outnumber the infinite paintings of its skies.

Though I am completely happy with a canvas of pure blue, let my palette share the reds, pinks, fuchsias, and oranges. A lifetime of Colorado skies can define the breadth of chromatic variety as no rainbow, no under-the-seascape, and no psychedelic trip can! For those of us with senses stimulated in large part by color, the ultimate satiation is an evening's worth of sunset light cast onto cirrus clouds high in the atmosphere.

Let the wedding begin, as the silhouettes of things that define Colorado—rounded hills, canine peaks, pointed conifers—embrace the sky. This marriage of form and color whirls around us as we spin on our heels and try to consume each and every degree of nature's domed observatory. I hope you will enjoy twenty years worth of Colorado skies!

Other fine books by John Fielder:

John Fielder's Best of Colorado (2002)
Colorado: 1870–2000 Revisited (2001)
Colorado: 1870–2000 (1999)
A Colorado Winter (1998)
Along Colorado's Continental Divide Trail (1997)
Colorado's Continental Divide Trail: The Official Guide (1997)
Photographing the Landscape: The Art of Seeing (1996)
Explore Colorado: A Naturalist's Notebook (1995)
Rocky Mountain National Park: A 100 Year Perspective (1995)
A Colorado Autumn (1994)
Colorado Reflections Littlebook (1994)
Colorado Waterfalls Littlebook (1994)

Colorado Wildflowers Littlebook (1994)
The Complete Guide to Colorado's Wilderness Areas (1994)
A Colorado Kind of Christmas (1993)
To Walk in Wilderness: A Colorado Rocky Mountain Journal (1993)
Along the Colorado Trail (1992)
Colorado's Canyon Country: A Guide to Hiking & Floating BLM Wildlands (1992)
Colorado, Lost Places and Forgotten Words (1989)

Also look for John Fielder's Colorado wall and engagement calendars. John Fielder's images are also available as limited edition prints and stock photography. For more information, contact Westcliffe Publishers or visit online at www.johnfielder.com.

Opposite: *Morning clouds fill the Arkansas River valley*

Nobody of any real culture, for instance, ever talks nowadays about the beauty of sunset. Sunsets are quite old fashioned. . . . To admire them is a distinct sign of provincialism of temperament. Upon the other hand they go on.

—*Oscar Wilde*

Evening twilight in southwestern Colorado

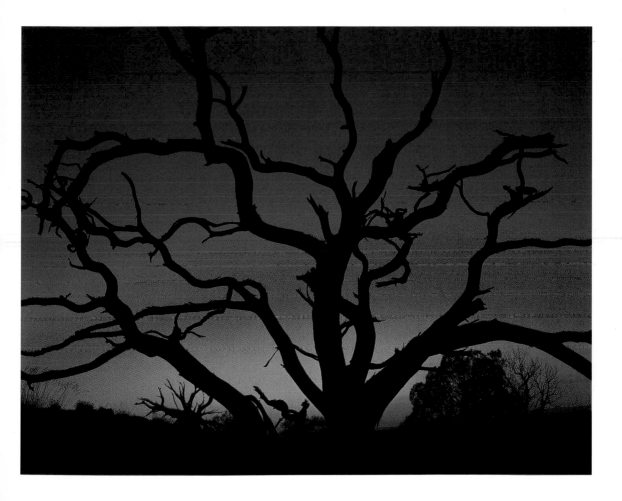

\mathcal{A} blue sky of spring,
White clouds on the wing:
What a little thing
To remember for years—

—*William Allingham*

Clouds and moon,
Maroon Bells-Snowmass Wilderness

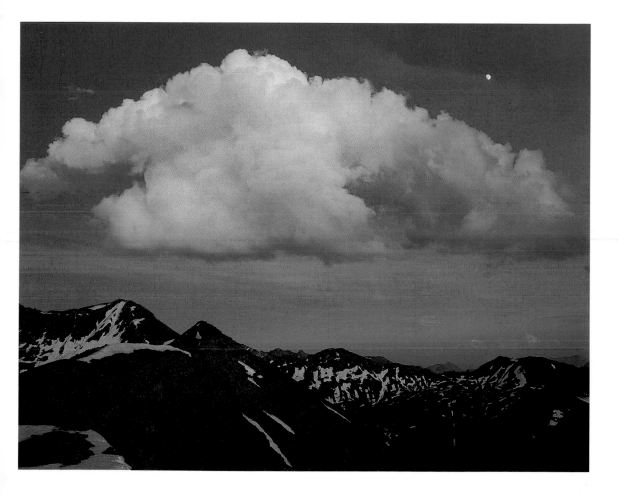

The cloud controls the light . . . It is the cloud that, holding the sun's rays in a sheaf as a giant holds a handful of spears, strikes the horizon, touches the extreme edge with a delicate revelation of light, or suddenly puts it out and makes the foreground shine.

—*Alice Meynell*

Sunrays in the Weminuche Wilderness

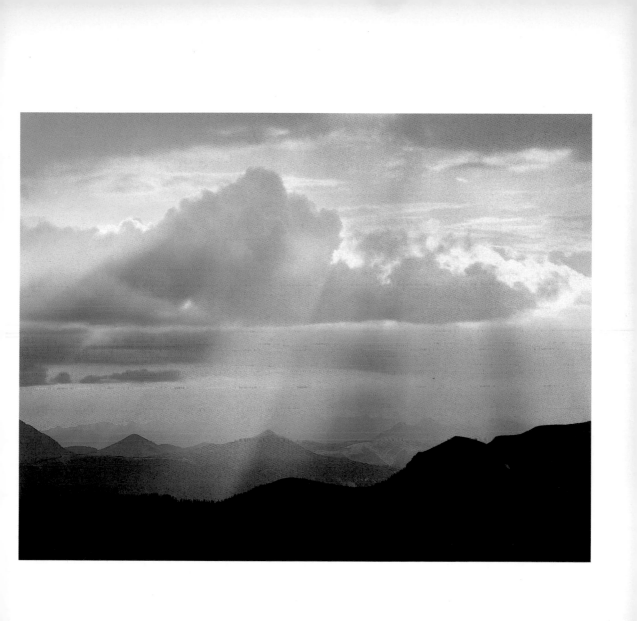

The mountain at a given distance
 In amber lies;
Approached, the amber flits a little,—
 And that's the skies!

—*Emily Dickinson*

Sunset near Steamboat Springs

I long for scenes where man hath never trod
A place where woman never smiled or wept
There to abide with my Creator God
And sleep as I in childhood sweetly slept,
Untroubling and untroubled where I lie
The grass below, above, the vaulted sky.

—*John Clare*

Storm clouds over Archuleta Lake,
Weminuche Wilderness

Overleaf: *Sunset in the Collegiate Peaks Wilderness*

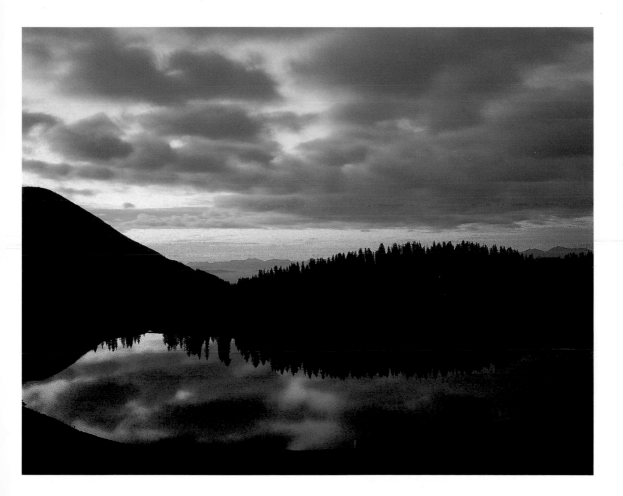

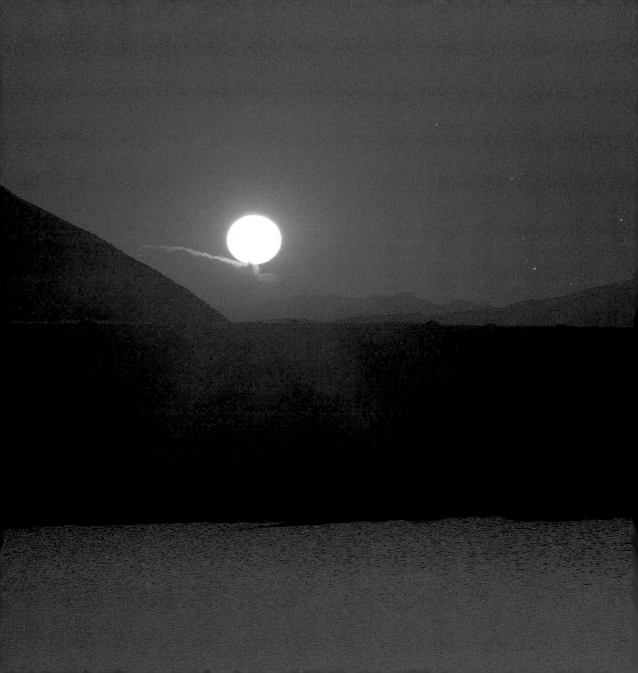

The sky . . . a gentian blue.
The clouds hurry and scurry as if in play.
What a wealth of color everywhere!
What extravagance of decoration!
What a painter is Nature!

—*Caroline A.S. Creevey*

Clouds over Rocky Mountain National Park

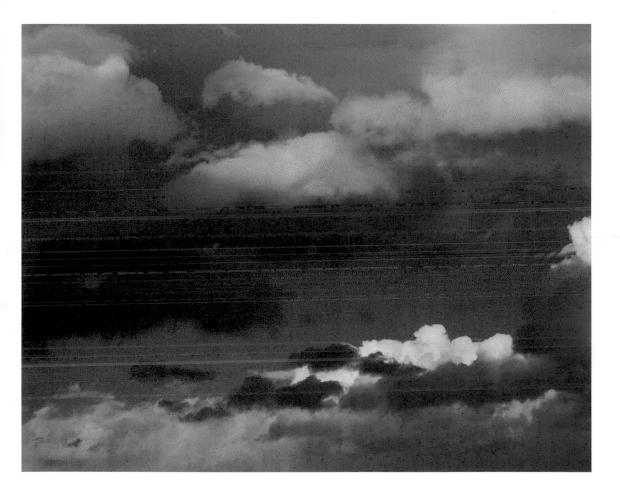

To see the Summer Sky
Is Poetry, though never in a Book it lie—
True Poems flee—

—*Emily Dickinson*

Sunrise, Eagles Nest Wilderness

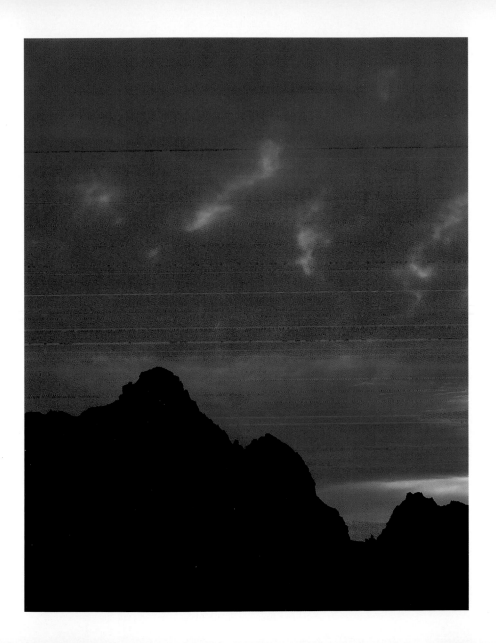

*H*ere are the long heavy winds
and breathless calms . . .
where dust devils dance, whirling
up into a wide, pale sky.

—*Mary Austin*

Horsetails over the Rawah Wilderness

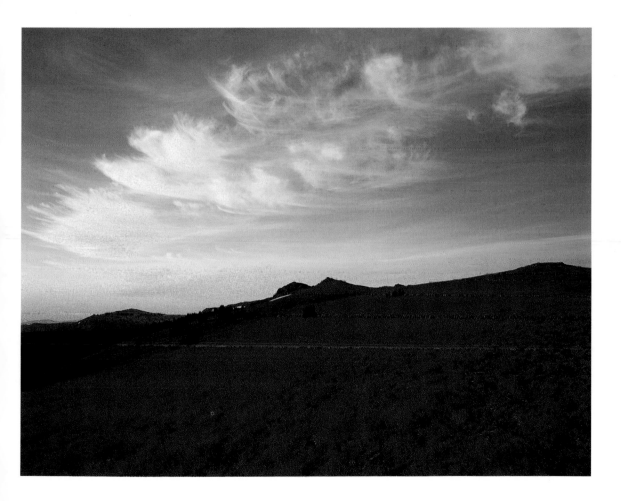

Down sank the great red sun, and in golden,
 glimmering vapors
Veiled the light of his face, like the Prophet
 descending from Sinai.

—*Henry Wadsworth Longfellow*

Sunset, Greenwood Village

As the bare green hill
When some soft cloud vanishes into rain,
Laughs with a thousand drops of sunny water
To the unpavilioned sky!

—*Percy Bysshe Shelley*

Morning mist, Weminuche Wilderness

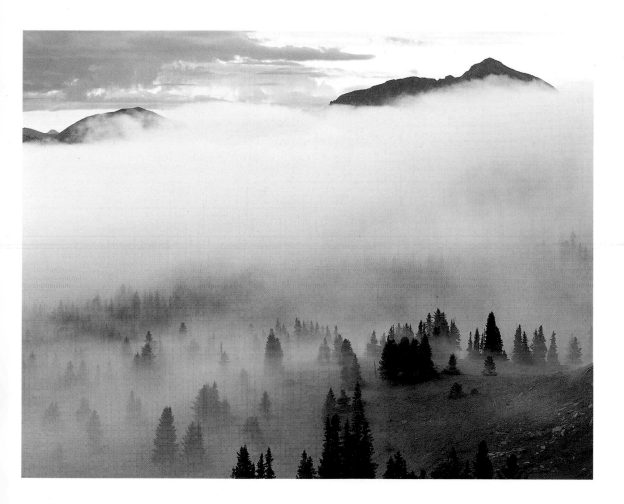

*I*t is true, I never assisted the sun materially in his rising; but, doubt not, it was of the last importance only to be present at it.

—*Henry David Thoreau*

Capitol Peak at morning twilight

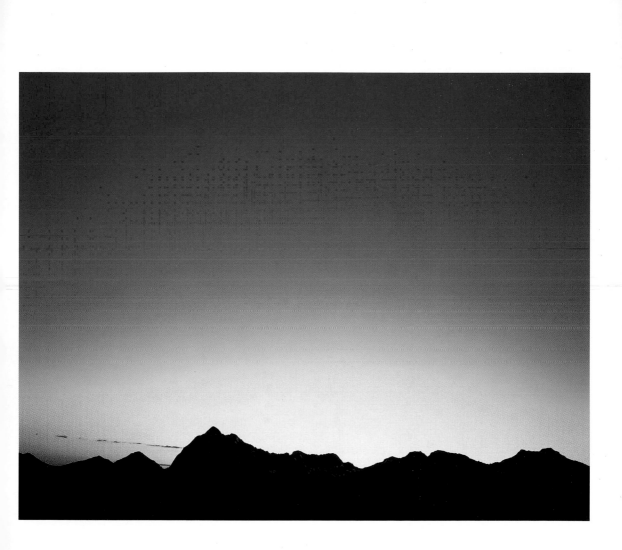

Sometimes gentle, sometimes capricious, sometimes awful, never the same for two moments together; almost human in its passions, almost spiritual in its tenderness, almost Divine in its infinity.

—*John Ruskin*

Sunrise, Uncompahgre Wilderness

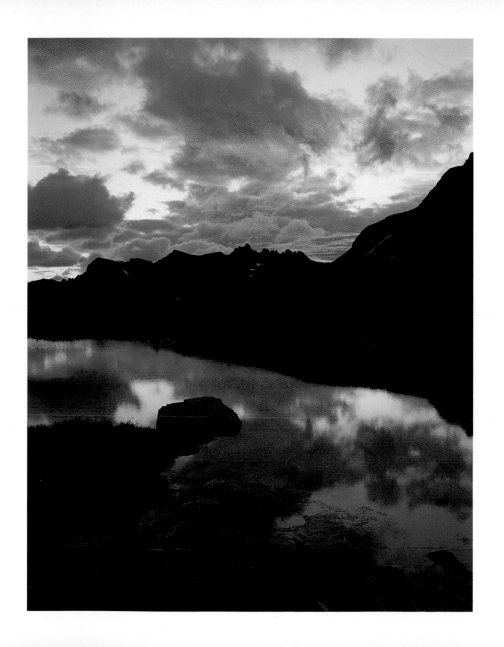

Nature is always kind enough to give even
her clouds a humorous lining.

—*James Russell Lowell*

Cumulus clouds, eastern Colorado

Overleaf: *Moonrise, Powderhorn Wilderness*

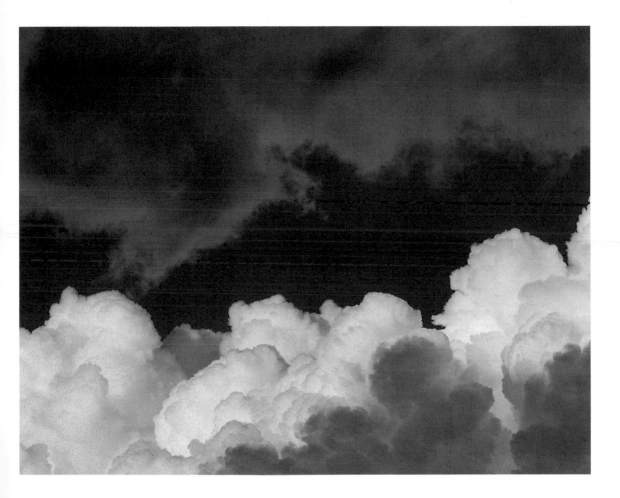

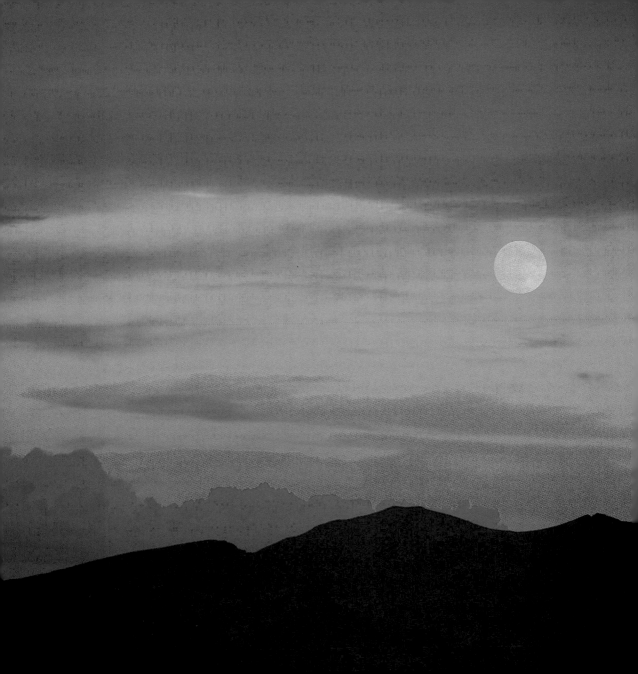

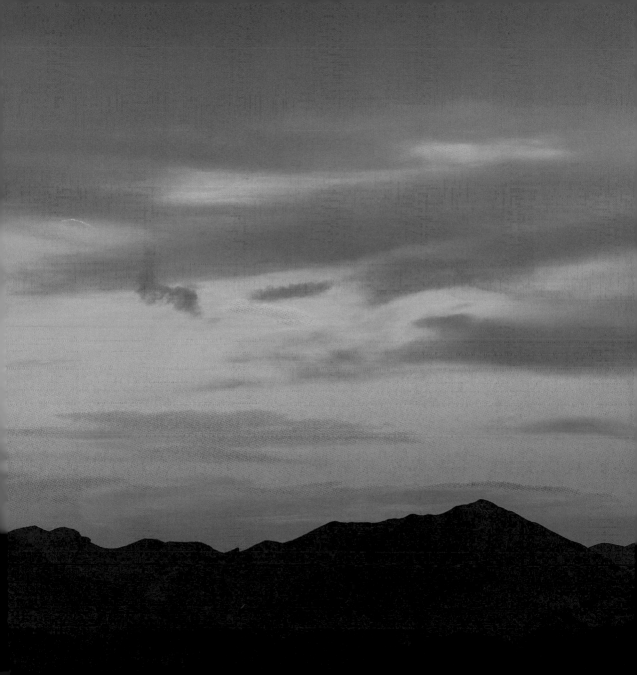

The sun was like a great visiting presence that stimulated and took its due from all animal energy. When it flung wide its cloak and stepped down over the edge of the fields at evening, it left behind it a spent and exhausted world.

—*Willa Cather*

Anvil cloud at sunset,
Comanche National Grassland

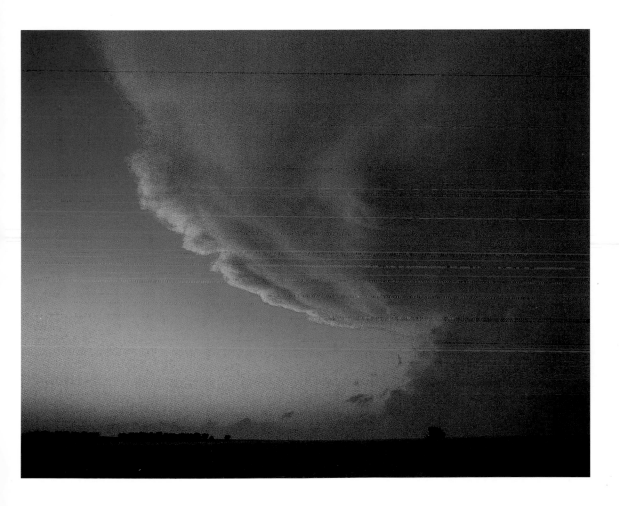

And the blue sky, and in the mind of man—
A motion and a spirit, that impels
All thinking things, all objects of all thought,
And rolls through all things.

—*William Cullen Bryant*

Afternoon clouds,
Hunter-Fryingpan Wilderness

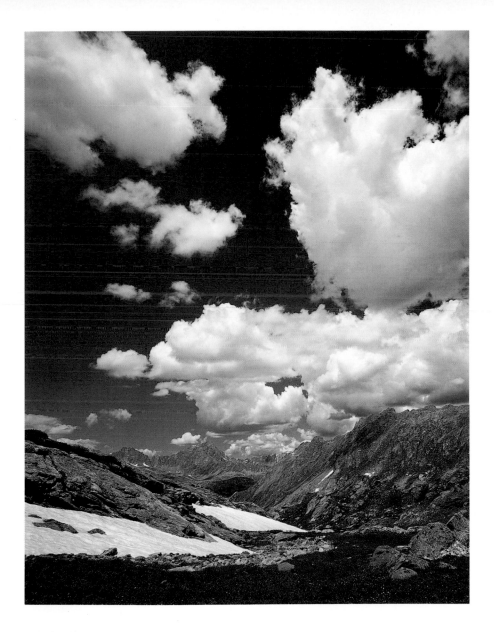

We talk of sunshine and moonshine, but not of cloud-shine, which is yet one of the illuminations of our skies. A shining cloud is one of the most majestic of all secondary lights.

—*Alice Meynell*

Sunset, Sangre de Cristo Range

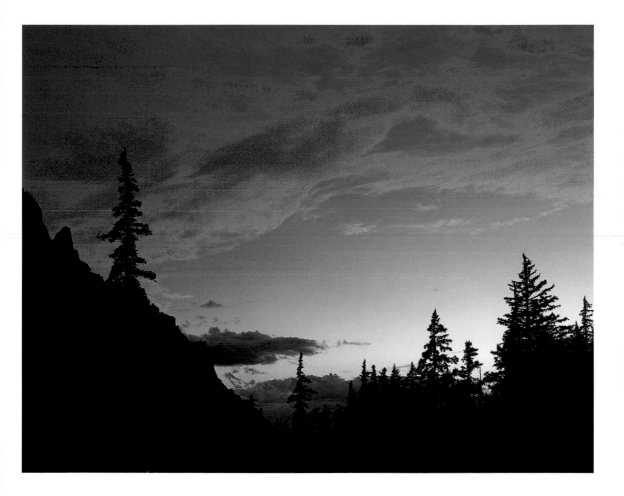

The sky is the daily bread of the eyes.

—*Ralph Waldo Emerson*

Mammato cumulus clouds at sunset,
eastern Colorado

The sky intense, . . . a day full
of strong light . . . as if there were
a diurnal aurora streaming up and
burning through the sunlight.

—*John Burroughs*

Sunrise on the Dolores River

Overleaf: *Wetterhorn and Uncompahgre peaks at morning twilight*

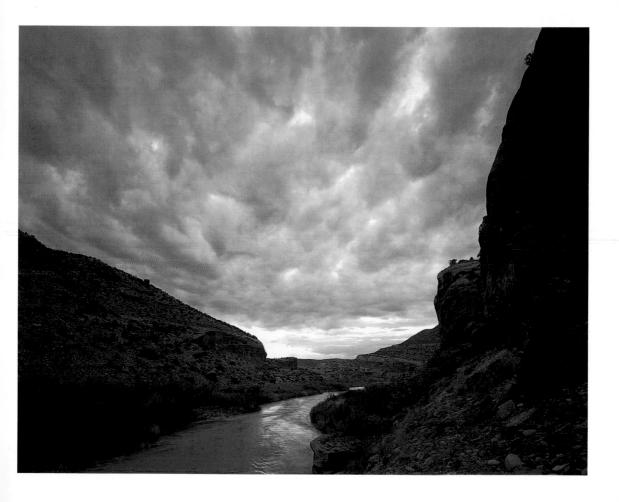

I'll tell you how the sun rose—
A ribbon at a time.

— *Emily Dickinson*

Sunrise over North Park

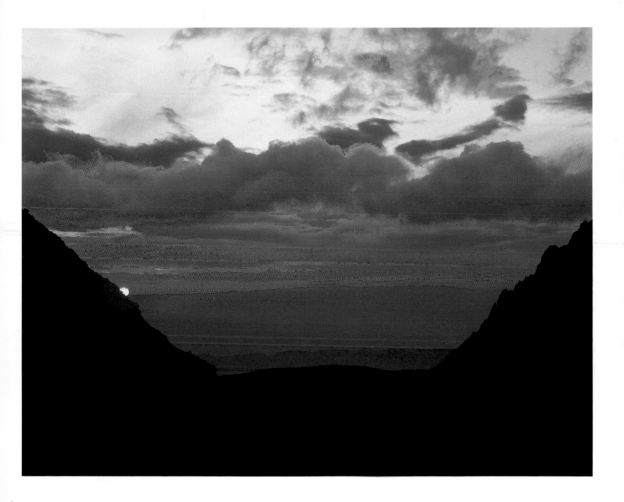

Terrestrial scenery is much, but it is not all. Men go in search of it; but the celestial scenery journeys to them; it goes its way round the world. It has no nation, it costs no weariness, it knows no bounds.

—*Alice Meynell*

Cumulus clouds over the Zirkel Wilderness

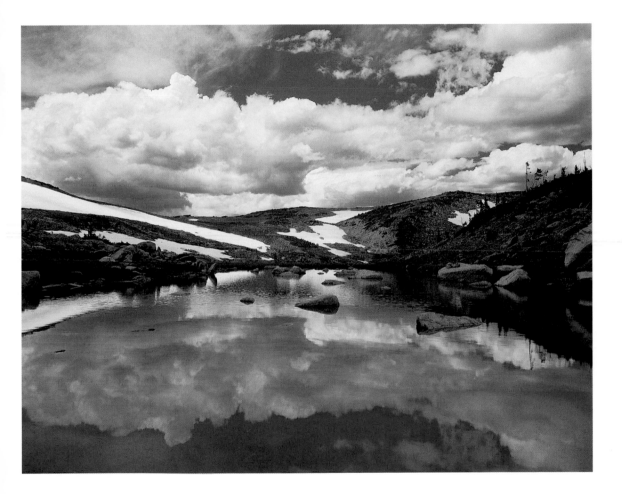

This most excellent canopy, . . . this
brave o'erhanging firmament, this majestical roof
fretted with golden fire . . .

—*William Shakespeare*

Sunrise from James Peak, Front Range

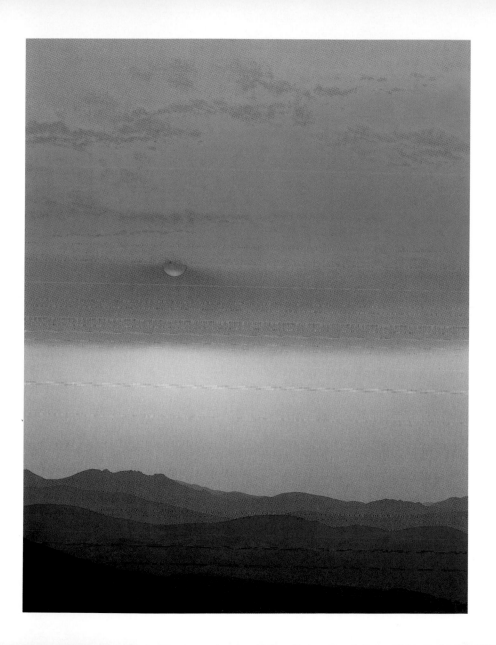

If the sight of the blue skies fills you
with joy, if a blade of grass springing
up in the fields has power to move you,
if the simple things of nature have a
message that you understand, rejoice,
for your soul is alive.

—*Eleonora Duse*

Sunrise at the Rio Grande Pyramid

Overleaf: *Buttermilk clouds in the morning, western Colorado*

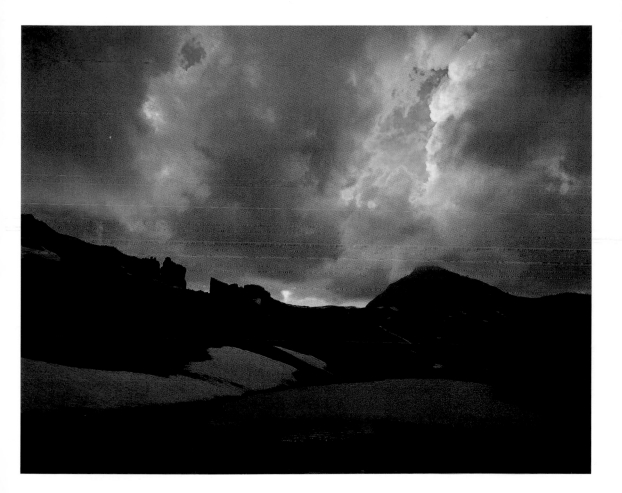

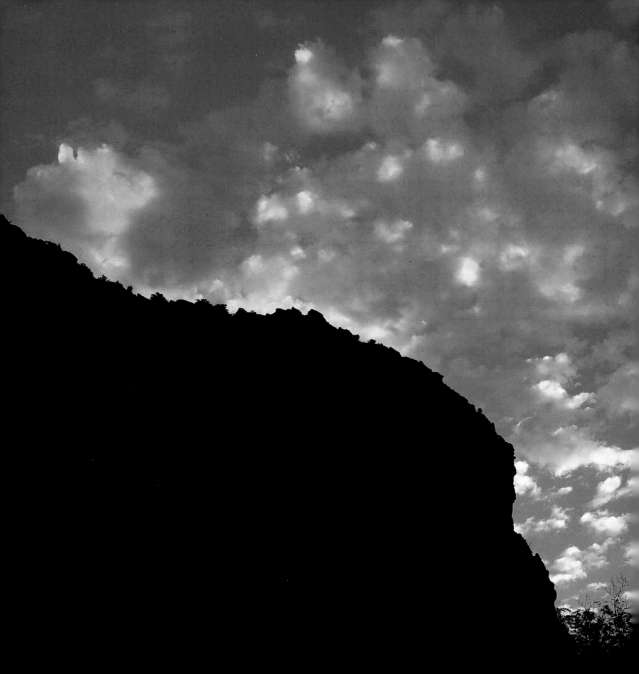

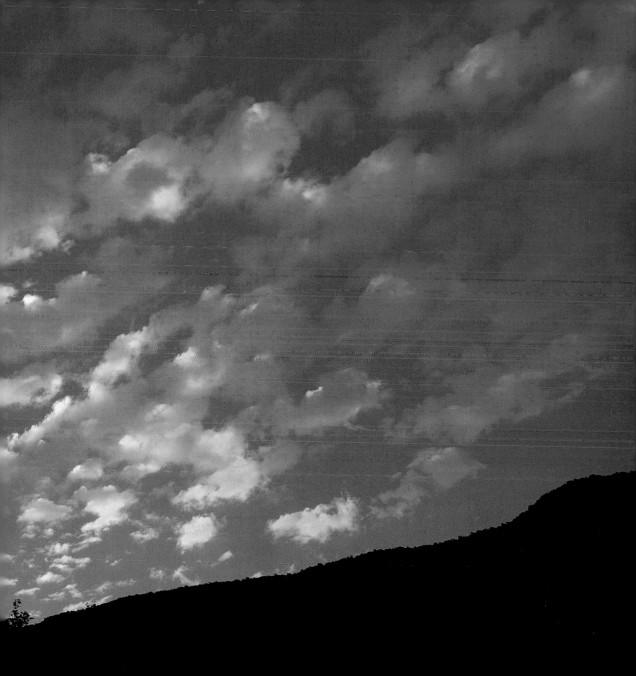

After a day of cloud and wind and rain
Sometimes the setting sun breaks out again,
 And touching all the darksome woods with light,
Smiles on the fields, until they laugh and sing,
Then like a ruby from the horizon's ring,
 Drops down into the night.

—*Henry Wadsworth Longfellow*

Sunset near Crested Butte

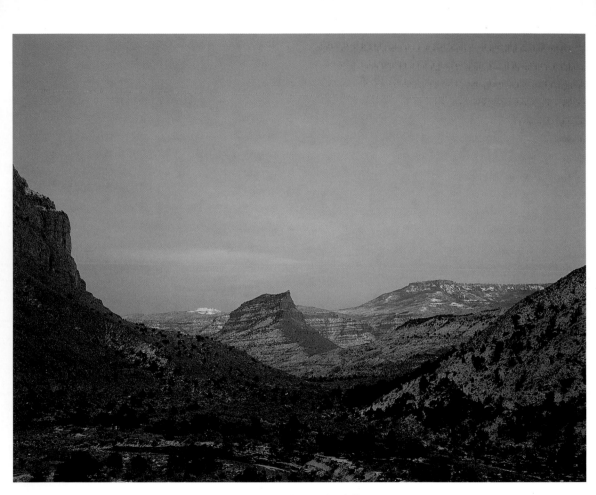

Sunset in the Book Cliffs